MW00532583

NEWFOUNDLAND
An Island Apart

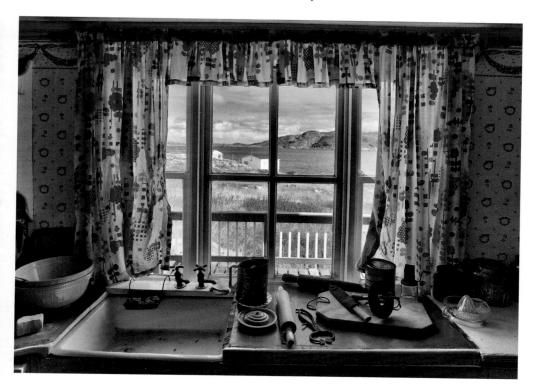

DENNIS MINTY

Breakwater

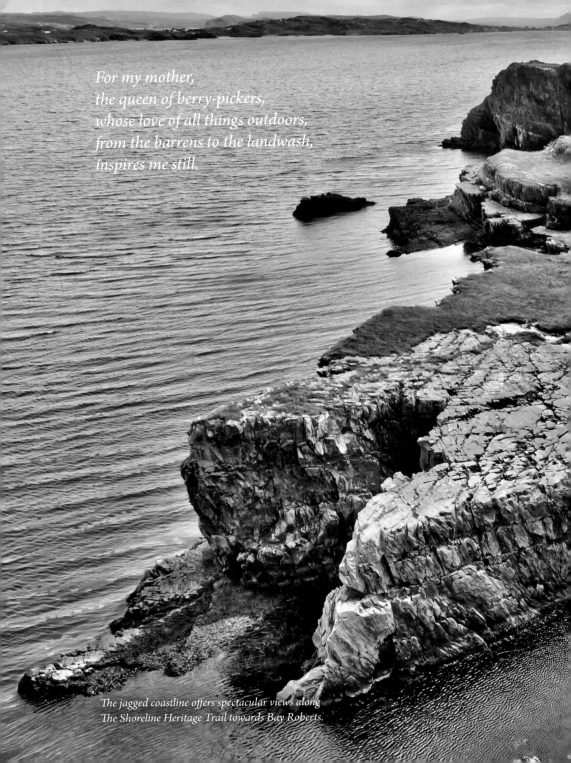

For my mother,
the queen of berry-pickers,
whose love of all things outdoors,
from the barrens to the landwash,
inspires me still.

The jagged coastline offers spectacular views along
The Shoreline Heritage Trail towards Bay Roberts.

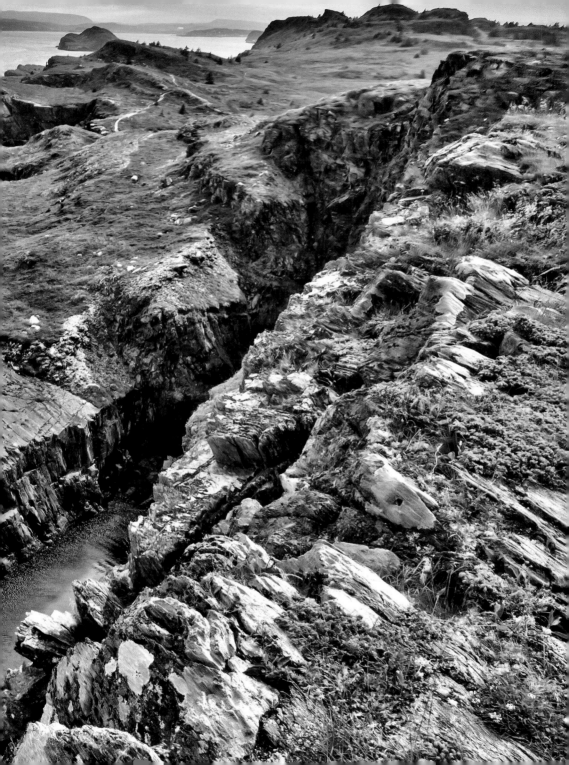

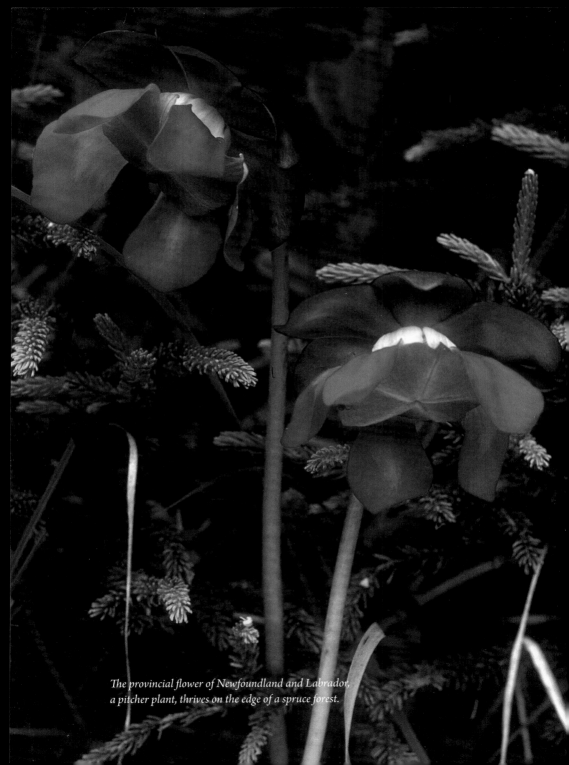

The provincial flower of Newfoundland and Labrador,
a pitcher plant, thrives on the edge of a spruce forest.

Introduction

To belong to a place is a gift. And I have been blessed with a profound and abiding sense of belonging to Newfoundland. My family has lived here for four generations before me, and my grandchildren comprise the seventh generation. As my birthplace and home, Newfoundland dominates my photography and my life more than any other place. For more than forty years as a photographer, I have been seeking out the island's gems and the light that washes over them.

Since the publication of my first book of Newfoundland images, *Wildland Visions*, the craft of photography has evolved and I with it. Starting as an enthusiast, I now make it my living. It is through photography, through learning the light and seeing the life of the landscape, that my connection with nature is the strongest. And this is how I've come to learn that the island of Newfoundland is a place apart.

Even the seasons here announce their arrival differently. Our spring does not occur as a sudden flourish, but rather pushes winter aside ever so slowly. On the northeast coast, March and April are the time of glorious sea ice sliding down on the Labrador Current and bringing with it harp seals and the occasional polar bear. The play of colour on the myriad glowing shapes is simply enchanting. The sea ice

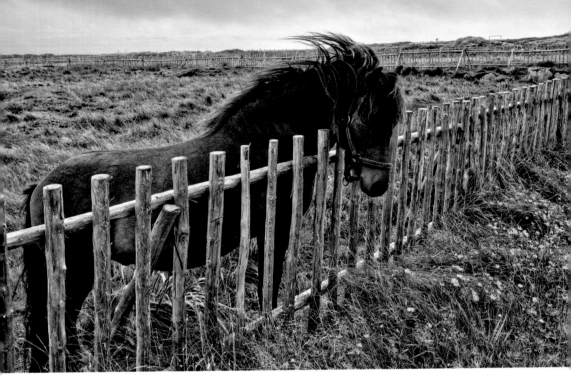

A hardy Newfoundland pony, bred for the island's rugged terrain,
pauses at the edge of his pasture on an overcast day in Tilting, Fogo Island.

is followed by the great ice giants, icebergs brought from Greenland and the Canadian Arctic on a sea path known to both navigators and locals as Iceberg Alley.

Then the seabirds and whales appear with certain knowledge that the capelin will soon roll and bring an abundance of life to beaches and waters around the island. Gradually, the days grow longer and warmer as summer takes over, and a saltwater tang caresses the clean, clear air. Days on the water feel heaven-sent. Whales and seabirds abound. It is a time to be out and about.

Then, far too soon, a crispness invades the wind, a single leaf turns yellow, and the first insinuation of fall seeps in. At first, it is a disappointment that summer is over so early, but then I embrace the fall, my favourite time of year. The mosquitoes are gone, hiking opportunities are plentiful, and shooting comes easy in the warm, long-shadowed light. Winter, with its snow storms, reshapes and

cleanses the landscape, turning rough, hard edges to soft forms that cast long, blue shadows across the land. Snowshoe-clad, I wander from shape to shape flicking up diamonds in my wake. Then, spring pushes winter aside ever so slowly.

I can be awed by the beauty and diversity of other places like Antarctica, the Hebrides, or the Rocky Mountains. I can photograph them and enjoy the process immensely. But the connection is different. They are not my place. I am a visitor. But in Newfoundland, I'm not a visitor. I *belong*. Just as the whales, seabirds, and caribou belong.

So with this book, small in size but large in spirit, I want to celebrate in images what this place means to me.

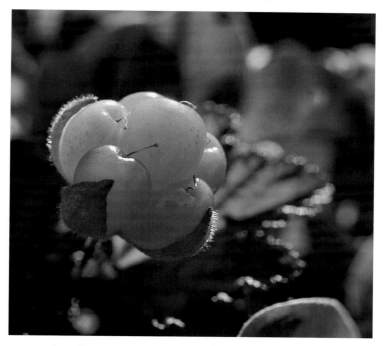

The amber ripeness of the bakeapple (known in other parts of the world as cloudberry) gleams in the morning sun. Found in bogs and marshes, the bakeapple is a favourite fruit in Newfoundland kitchens as it makes for delectable jams and spreads.

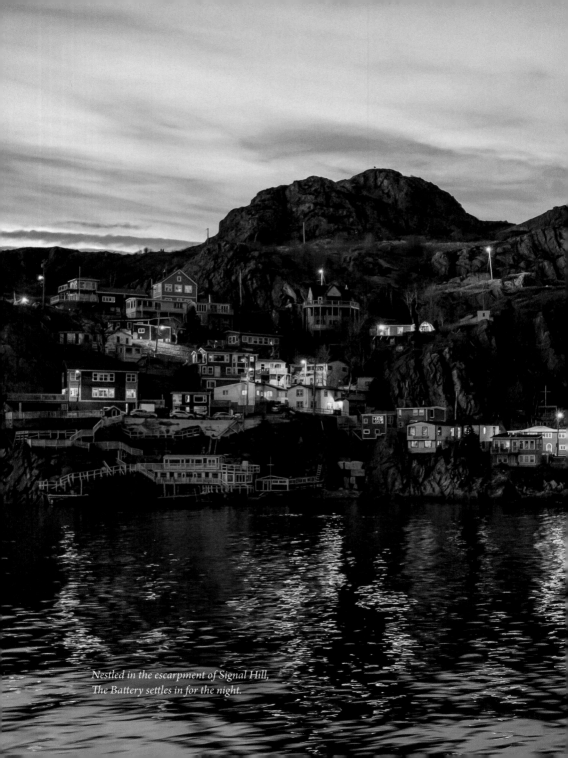

*Nestled in the escarpment of Signal Hill,
The Battery settles in for the night.*

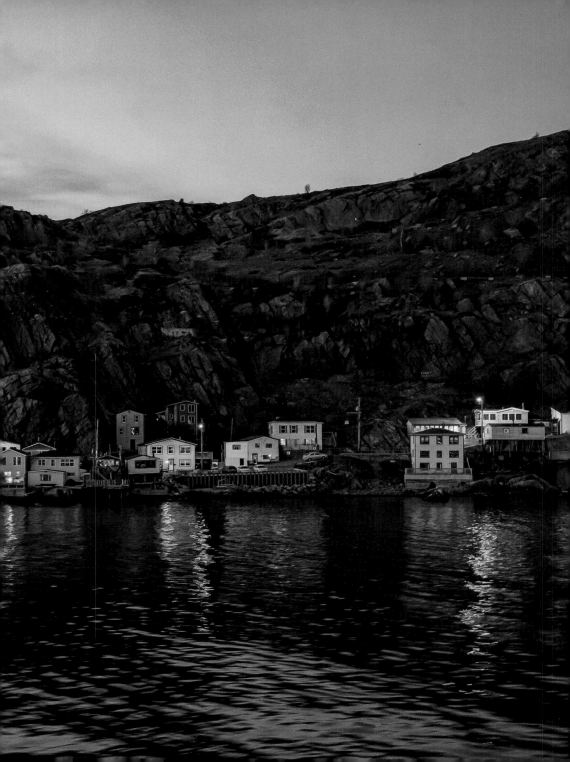

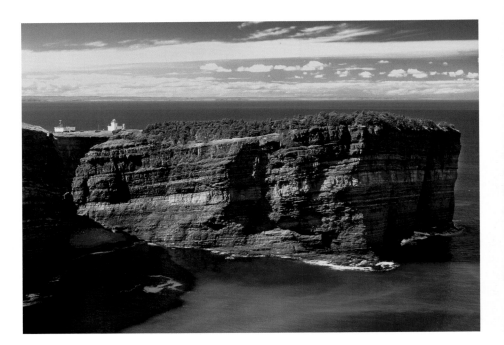

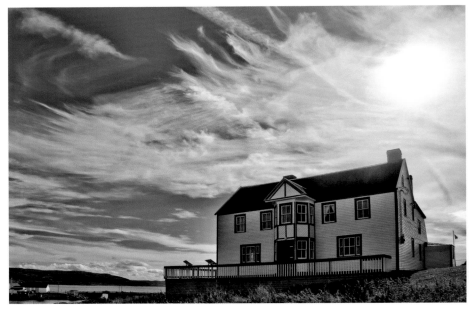

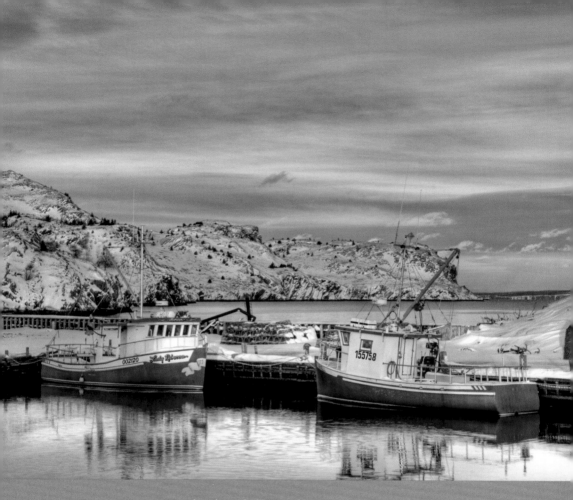

ABOVE: *Fishing boats find haven after an early snowfall in the safe harbour of historic Brigus.*

OPPOSITE TOP: *Bell Island rises dramatically from Conception Bay. In 1942, German U-boats sank four vessels off the coast of Bell Island. The island's former iron ore mines extend deep beneath the waters of the bay.*

OPPOSITE BOTTOM: *A majestic sky forms the backdrop for Bleak House in the town of Fogo. Now a museum, Bleak House was built in the early nineteenth century and was home to the most influential merchants in Fogo.*

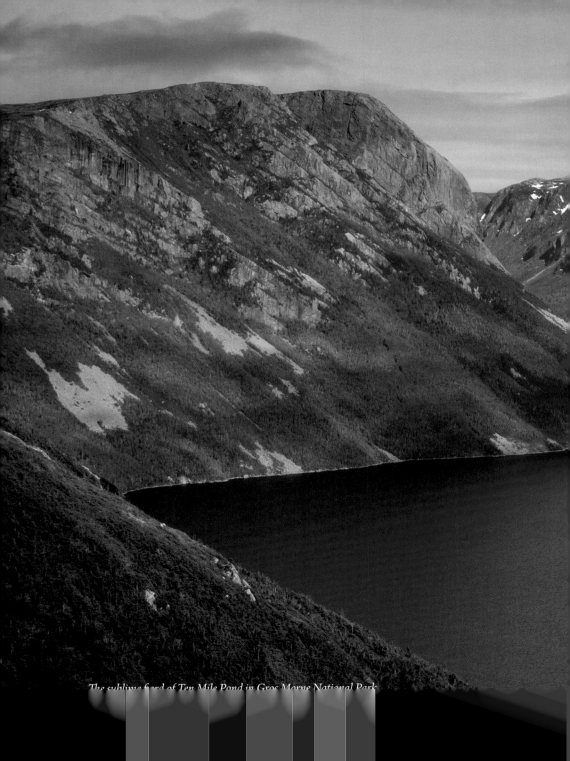

The sublime fjord of Ten Mile Pond in Gros Morne National Park

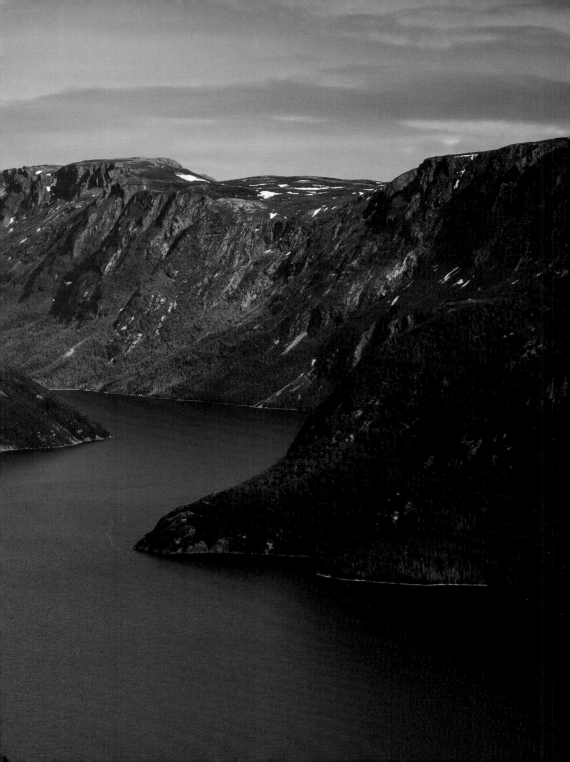

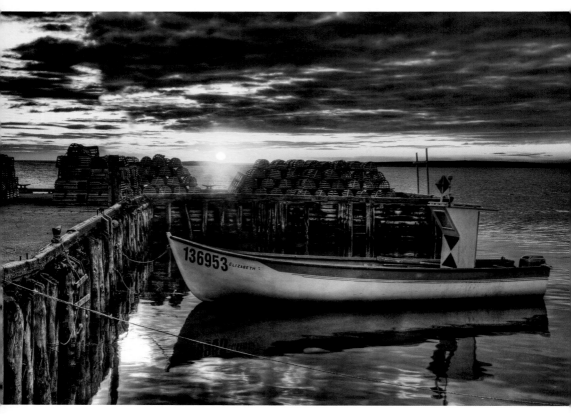

A calming sunset in Blue Cove on the Great Northern Peninsula.

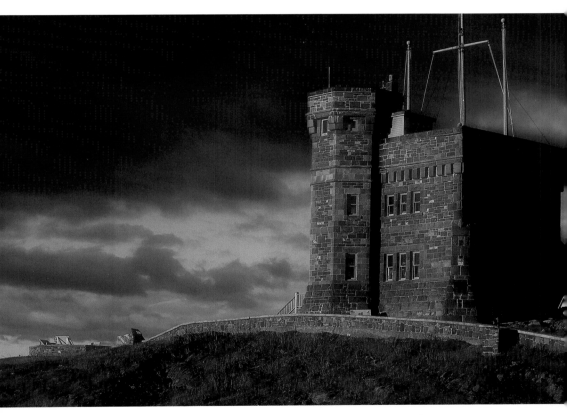

Cabot Tower stands as the centerpiece of the Signal Hill National Historic Site of Canada. Construction of the tower commenced in 1898 to mark the 400th anniversary of John Cabot's voyage to the island. It was here that Gugliemo Marconi received the world's first trans-Atlantic wireless message in 1901. However, the name Signal Hill is not related to Marconi. Rather, it refers to the flag signaling used to announce the arrival of incoming supply ships.

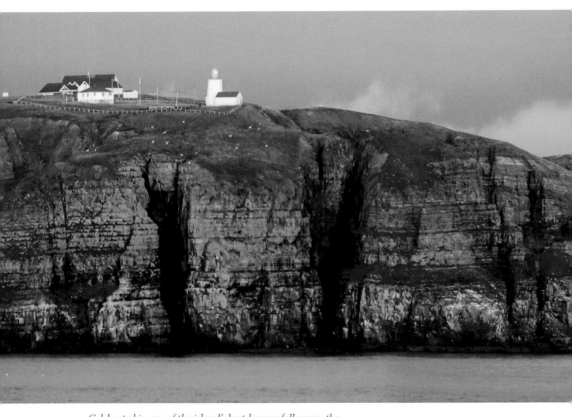

Celebrated in one of the island's best-known folksongs, the magnificent cliffs of Cape St. Mary's are home to Bird Rock and the Cape St. Mary's Ecological Reserve. Here, what looks like a snow-covered sea stack is actually the second largest gannet colony in North America.

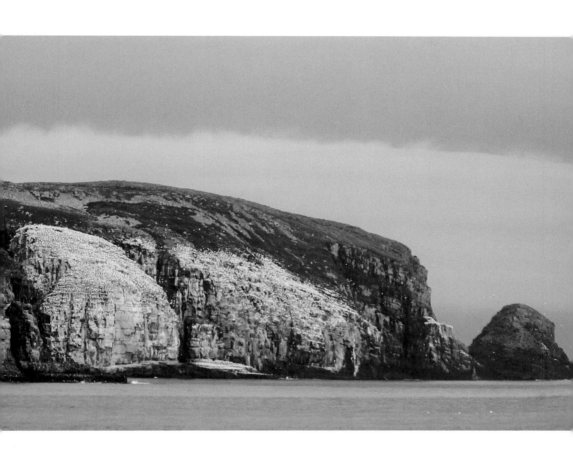

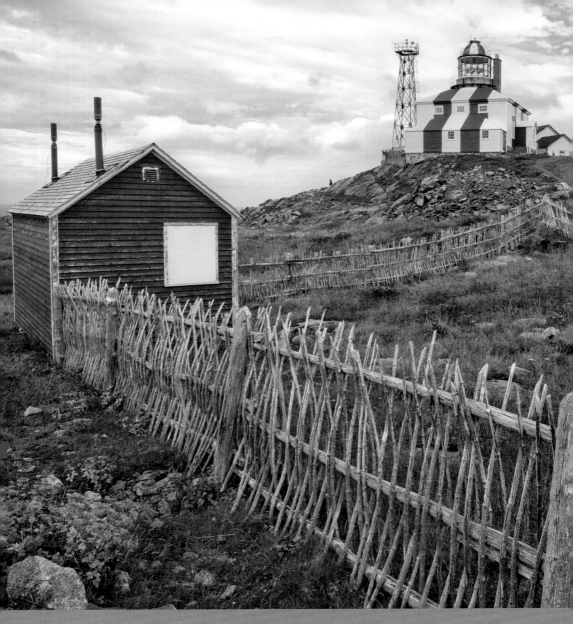

Situated on one of the island's most rugged points and surrounded by hyper-oceanic barrens, the lighthouse at Cape Bonavista stands now as it did in the late 1800s.

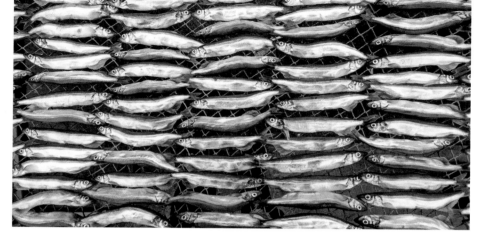

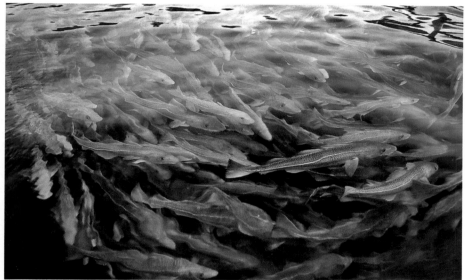

TOP: *Capelin drying on a flake. Near the beginning of every summer, these small silvery fish roll upon beaches around the island by the thousands to spawn.*

BOTTOM: *A school of codfish, one of the most compelling symbols of the island's history and culture.*

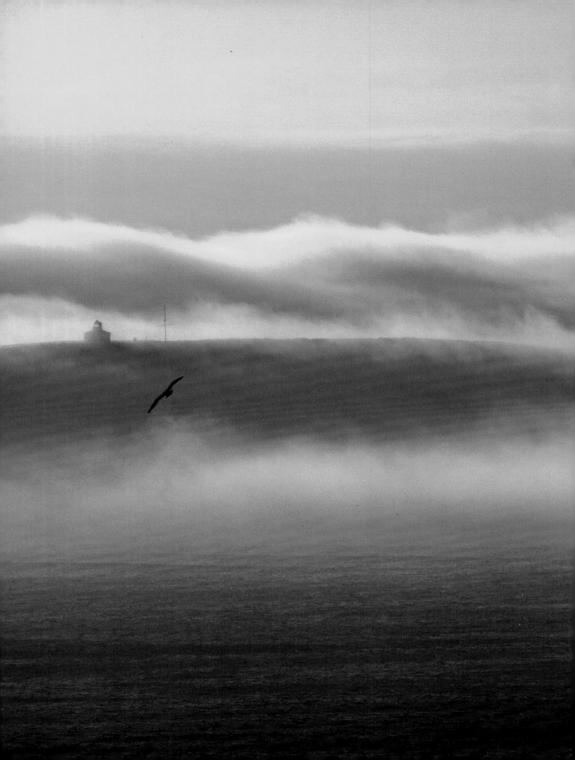

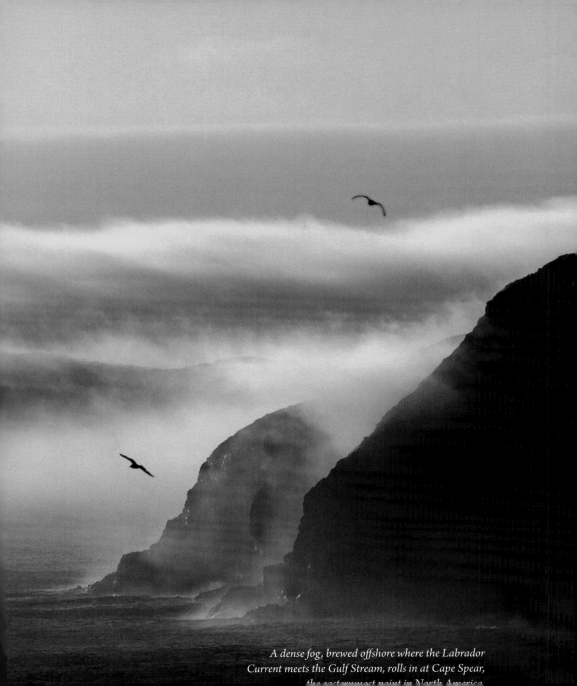

A dense fog, brewed offshore where the Labrador Current meets the Gulf Stream, rolls in at Cape Spear, the easternmost point in North America.

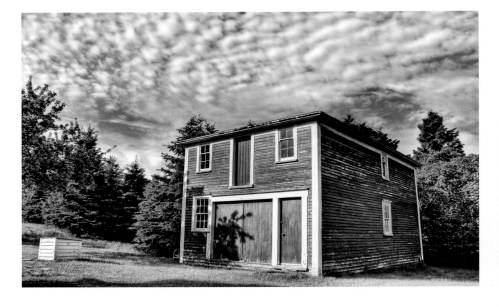

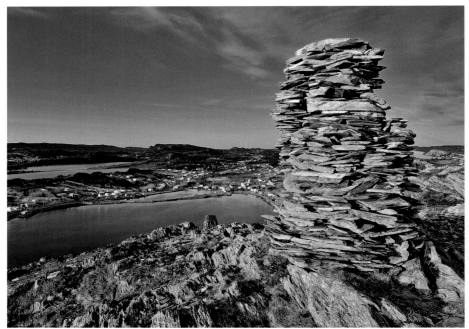

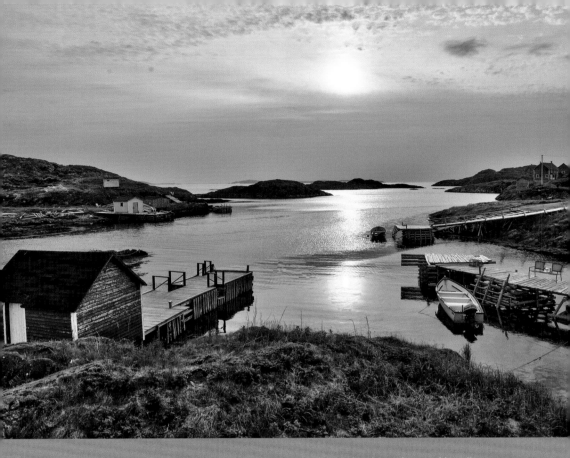

ABOVE: *Gazing out on the North Atlantic during a blessedly peaceful evening in Change Islands.*

OPPOSTIE TOP: *As shadows lengthen, the afternoon sun casts a perfect light on a barn in Cupids.*

OPPOSITE BOTTOM: *A hiker's perspective affords a glorious view of the rugged terrain around Cupids, the oldest, continuously settled English village in all of North America.*

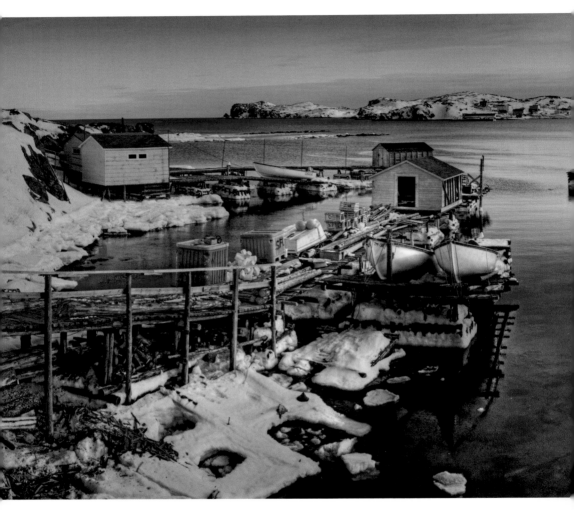

Snow and ice perfectly complement the blue hues of sea and sky on an evening of peace and tranquility in Durrell.

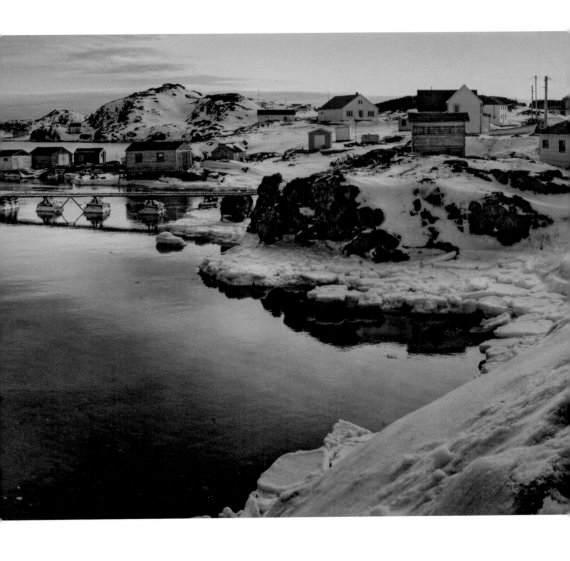

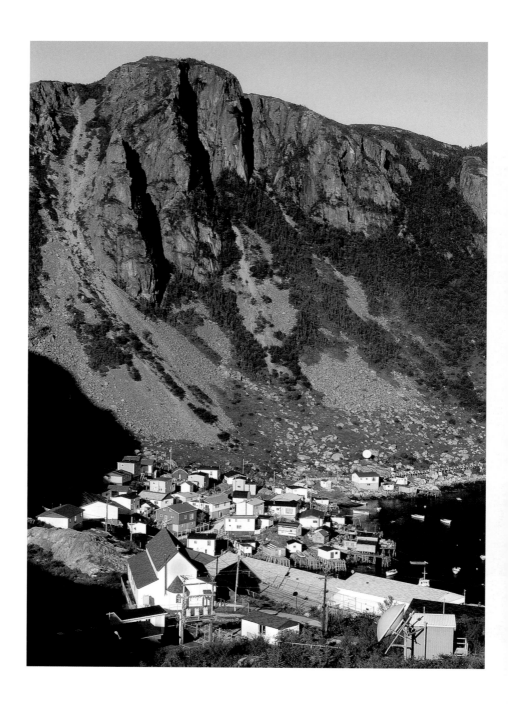

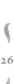

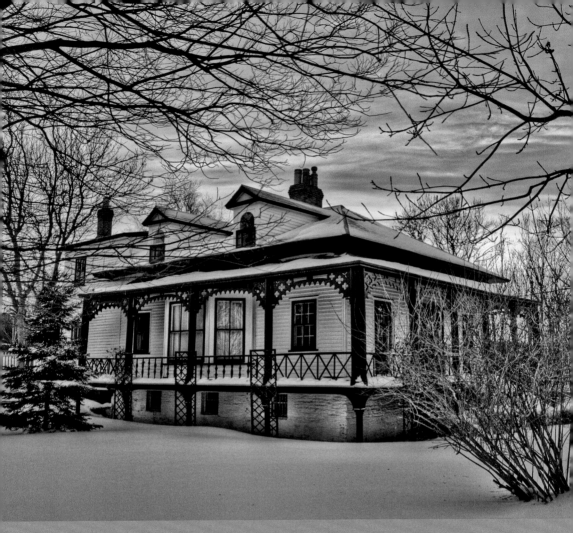

ABOVE: *A light dusting of snow accentuates the picturesque qualities of Hawthorne Cottage in Brigus. A National Historic Site, Hawthorne Cottage was once the home of the famous Artic explorer Captain Bob Bartlett.*

OPPOSITE: *The village of Francois rests cradled in the arms of a steep-walled fjord with the high rock formation known as The Friar in the background.*

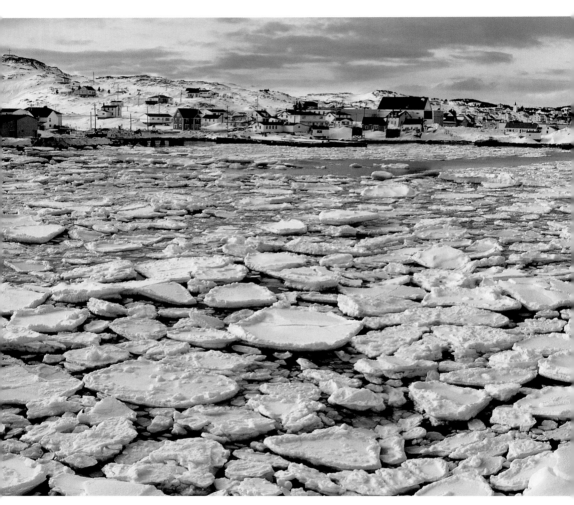

The spring break-up of ice in Twillingate on the island's northeast coast.

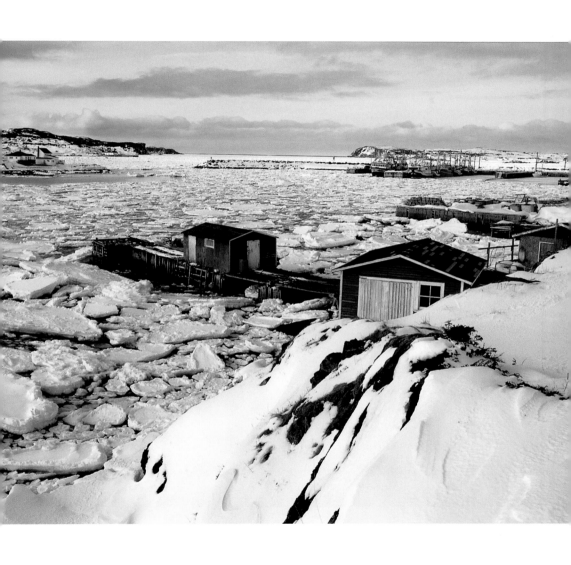

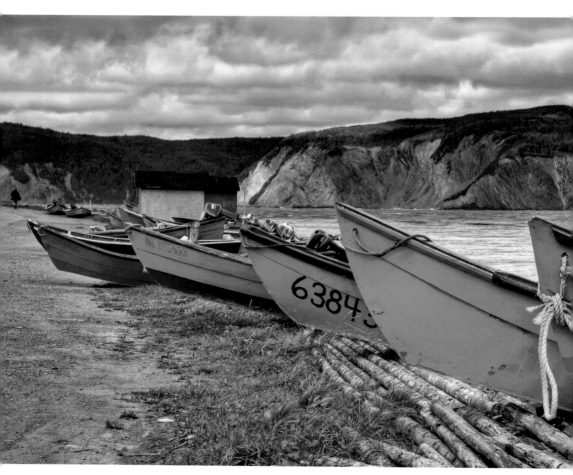

Boats hauled ashore under a darkening sky in Cox's Cove, Bay of Islands.

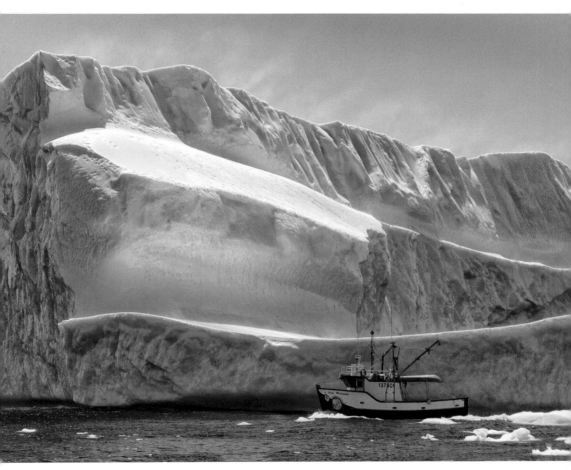

A massive ice giant dwarfs a longliner near St. Anthony.

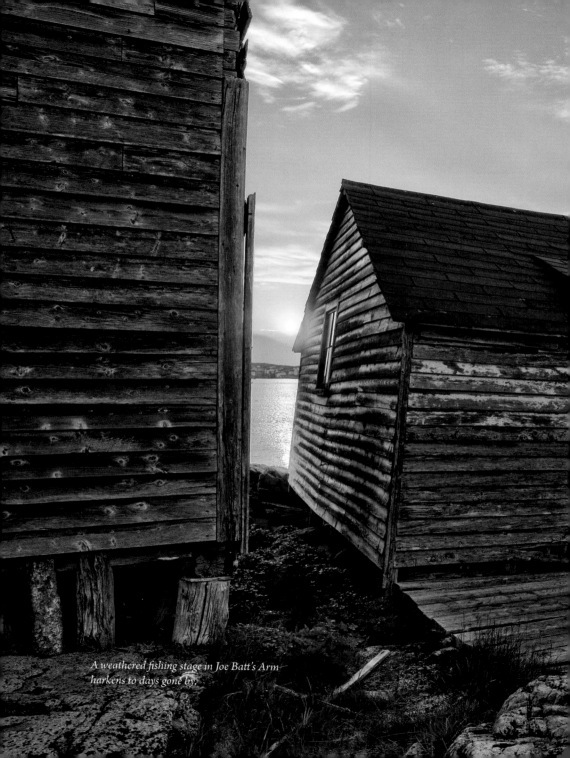

A weathered fishing stage in Joe Batt's Arm harkens to days gone by.

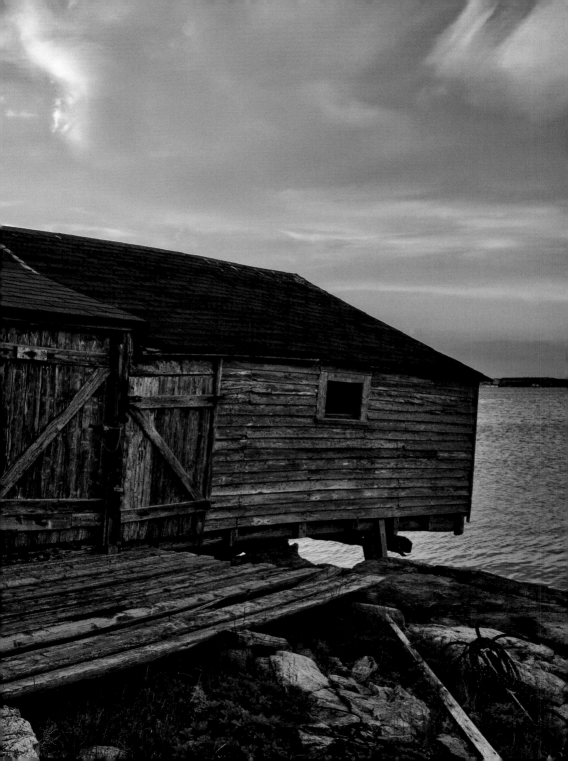

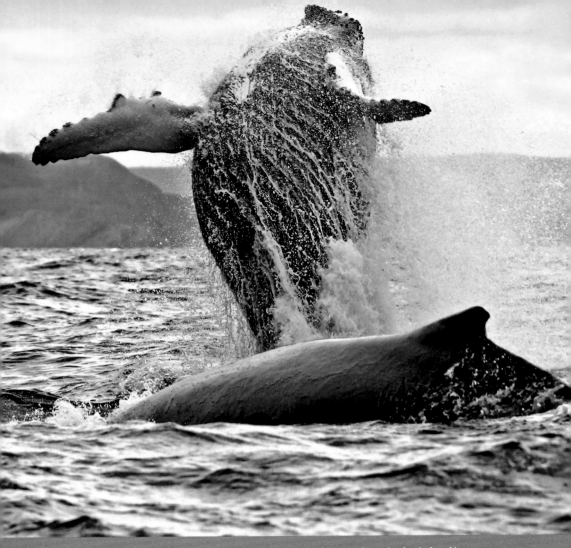

ABOVE: *In an incredible display of power and playfulness, a humpback whale calf breaches as its mother surfaces calmly nearby.*

OPPOSITE BOTTOM: *The village of La Poile, on the south coast, is a festival of colour in early autumn.*

BOTTOM: *The Viking settlement at L'Anse aux Meadows on the Great Northern Peninsula, a National Historic Site and the earliest known European settlement in the Americas. Here, the Vikings would have been the first Europeans to encounter members of the established North American indigenous population.*

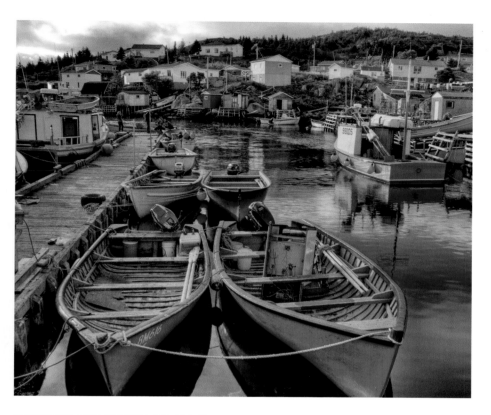

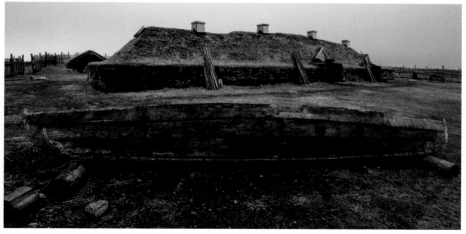

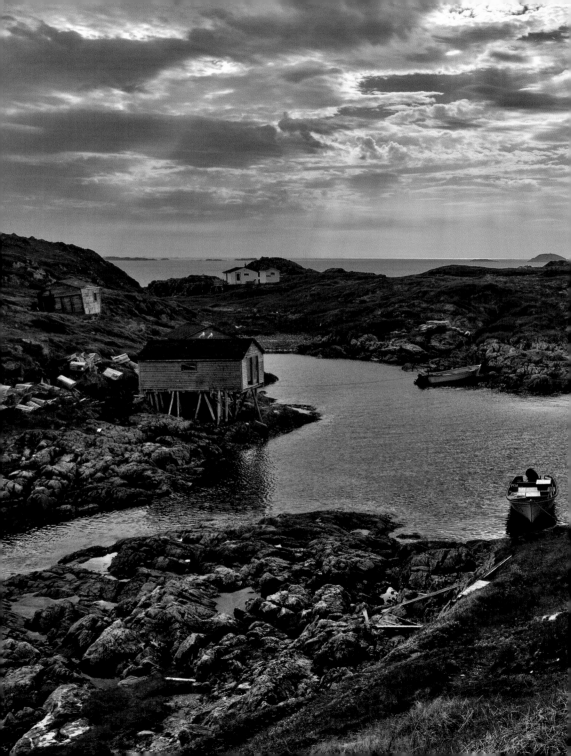

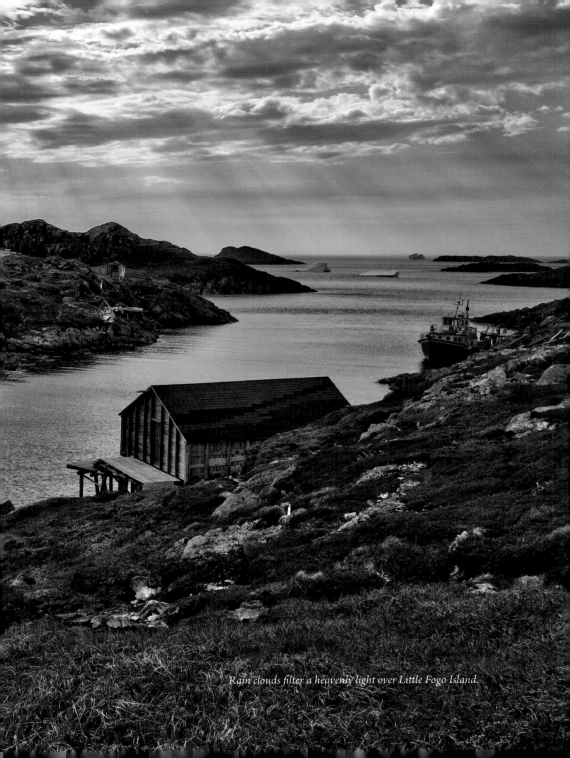

Rain clouds filter a heavenly light over Little Fogo Island.

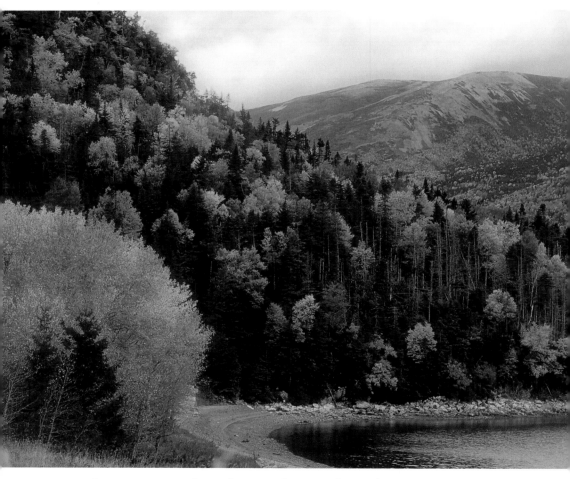

Autumn creates an explosion of energetic colours around Lomond River in Gros Morne National Park on the island's mountainous west coast.

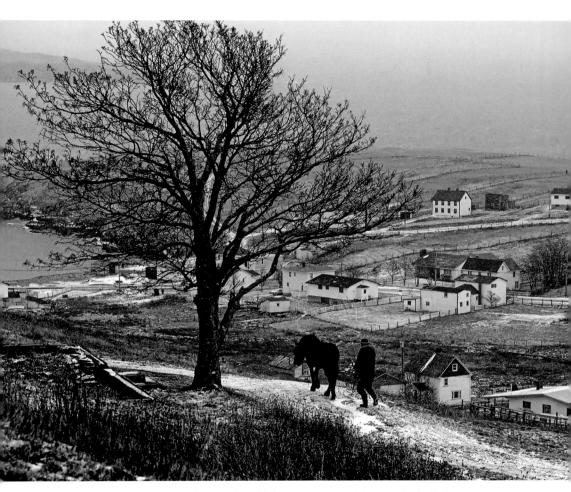

A man follows his horse on a chilly winter morning in Carbonear.

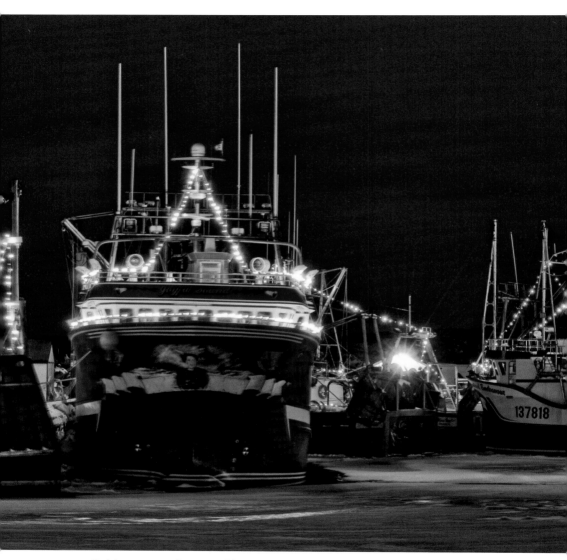

*Crab boats in Port de Grave celebrate the holiday season
with multicoloured lights against a winter sky.*

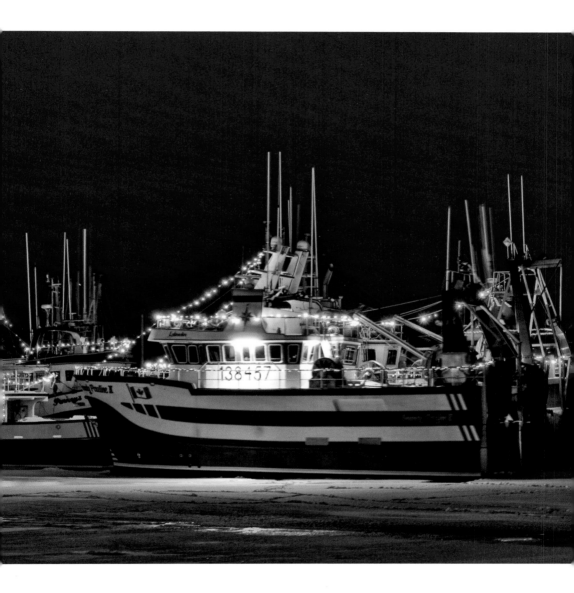

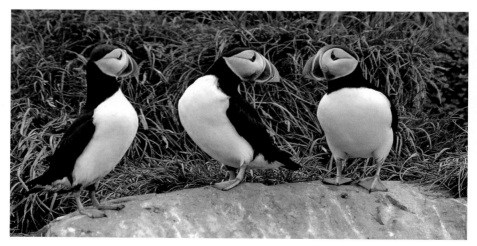

TOP: *A majestic bull moose emerges from cover into a brilliant light.*

BOTTOM: *Puffin gossip—three brilliantly beaked Atlantic puffins on Gull Island, Witless Bay.*

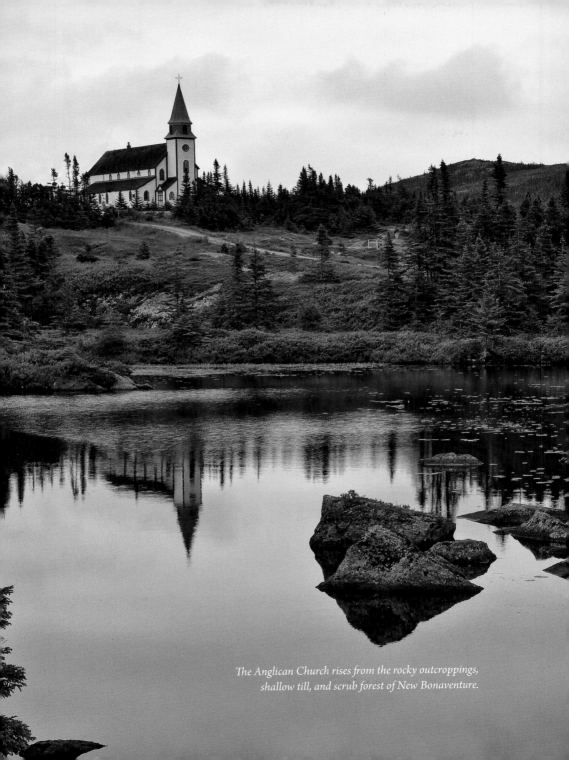

The Anglican Church rises from the rocky outcroppings, shallow till, and scrub forest of New Bonaventure.

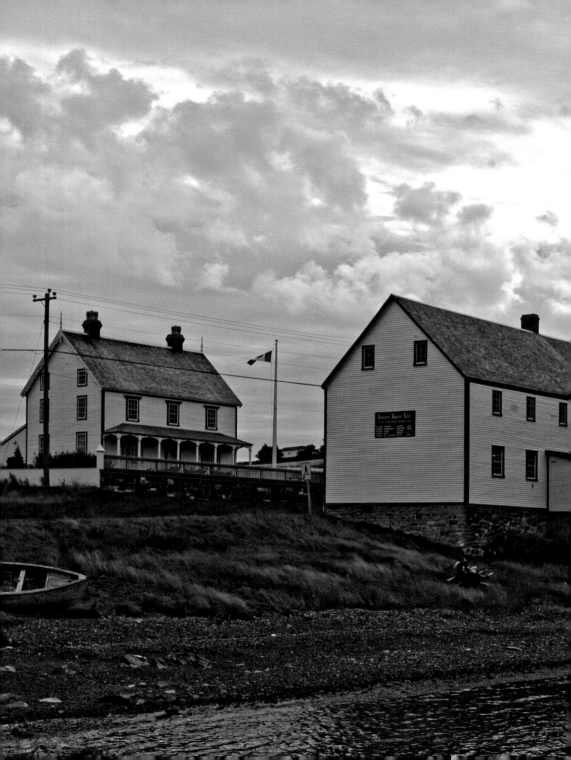

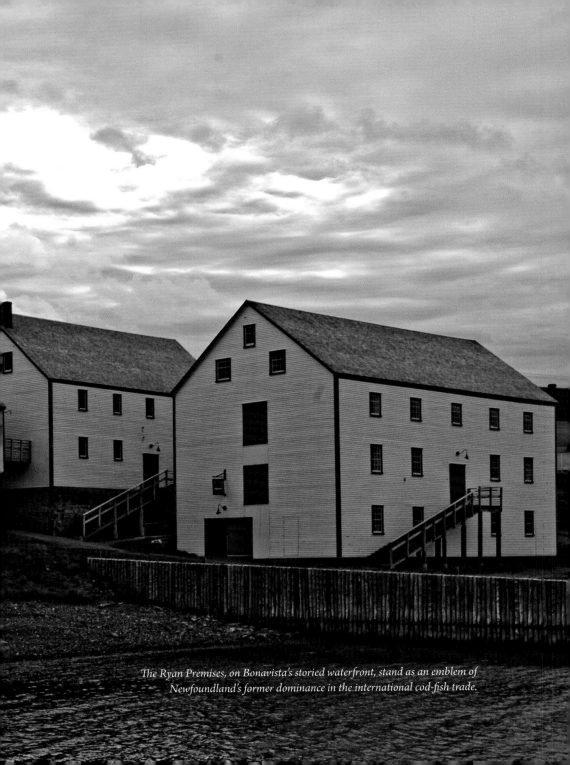

The Ryan Premises, on Bonavista's storied waterfront, stand as an emblem of Newfoundland's former dominance in the international cod-fish trade.

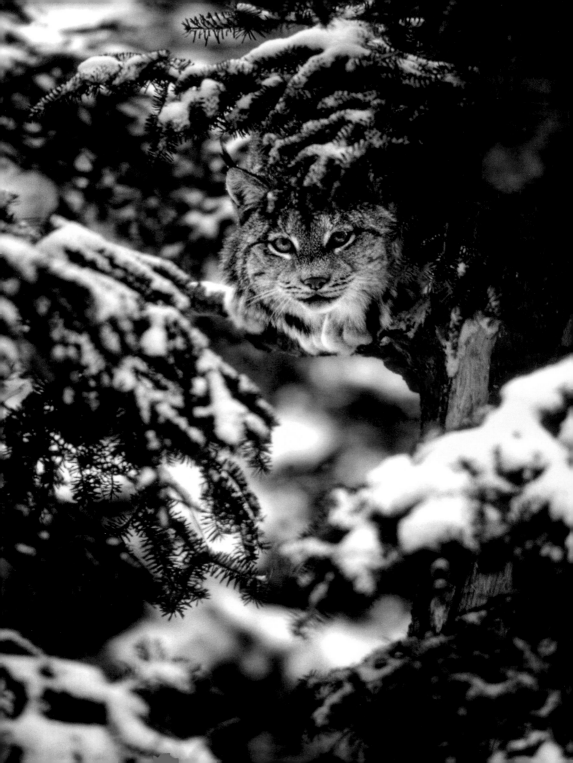

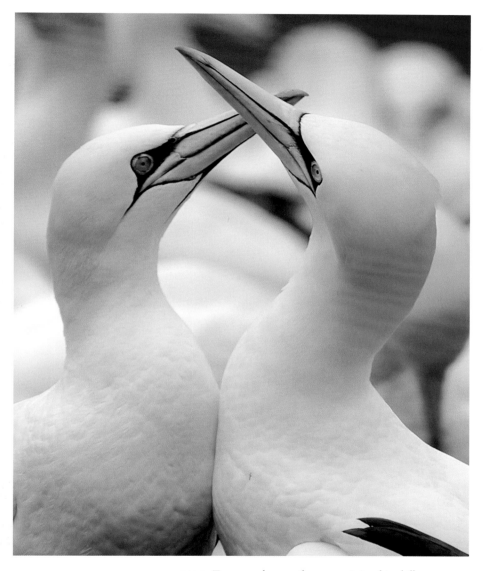

ABOVE: *Two marvelous northern gannets touching bills, a common greeting ritual, at Bird Rock, Cape St. Mary's Ecological Reserve.*

OPPOSITE: *The Newfoundland lynx is a rare and awe-inspiring sight among the fir trees of the island's boreal forest.*

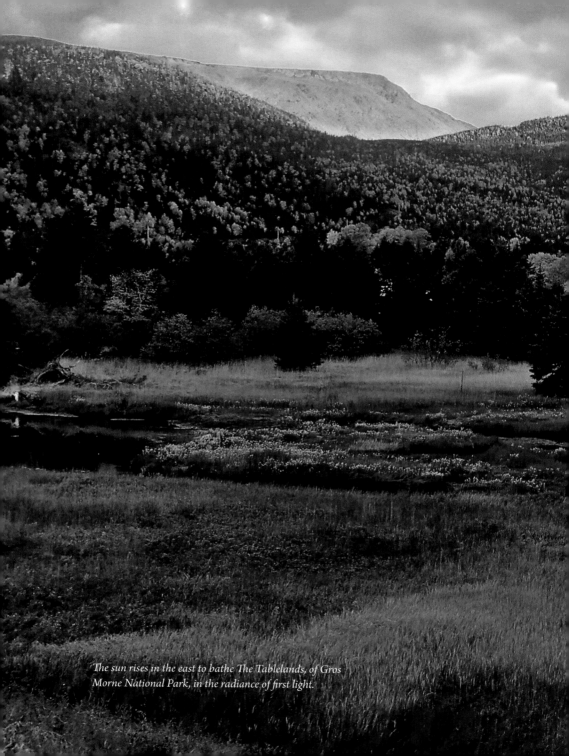

The sun rises in the east to bathe The Tablelands, of Gros Morne National Park, in the radiance of first light.

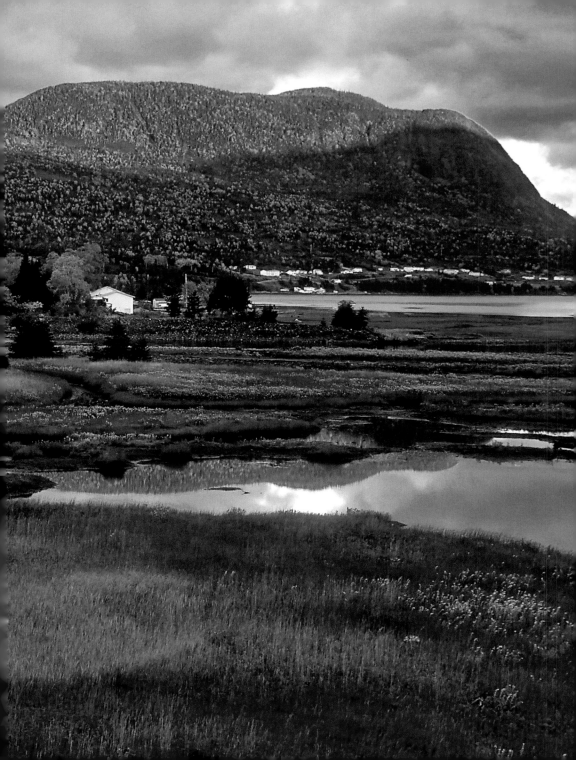

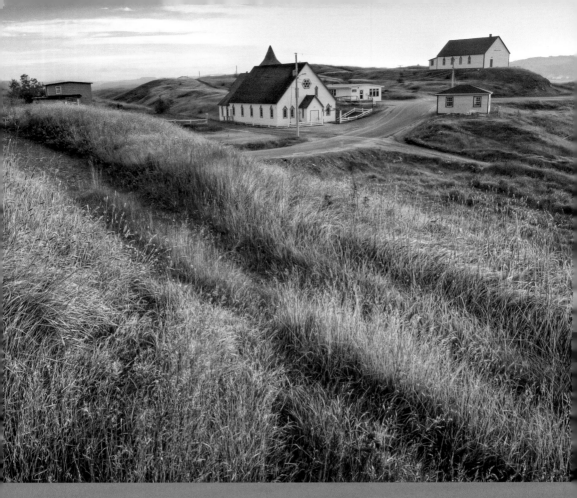

ABOVE: *The morning sun exposes a host of green hues in lush grasses on a walk through Port Rexton.*

OPPOSITE: *Spirited colours adorn the boats of Rocky Harbour, located in the heart of Gros Morne National Park, with Lobster Cove Lighthouse in the background.*

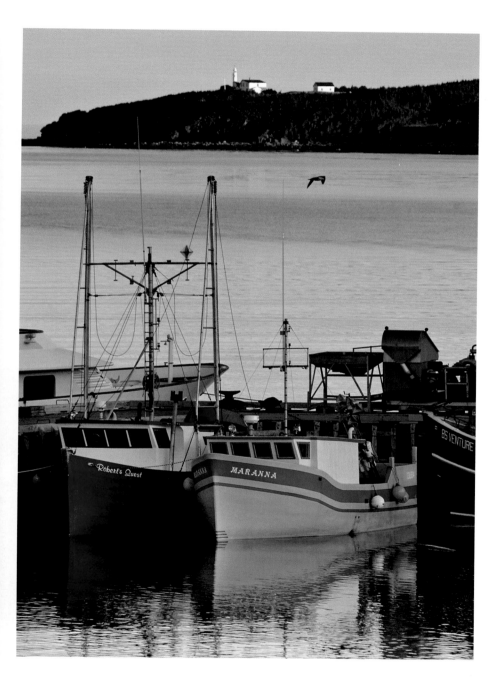

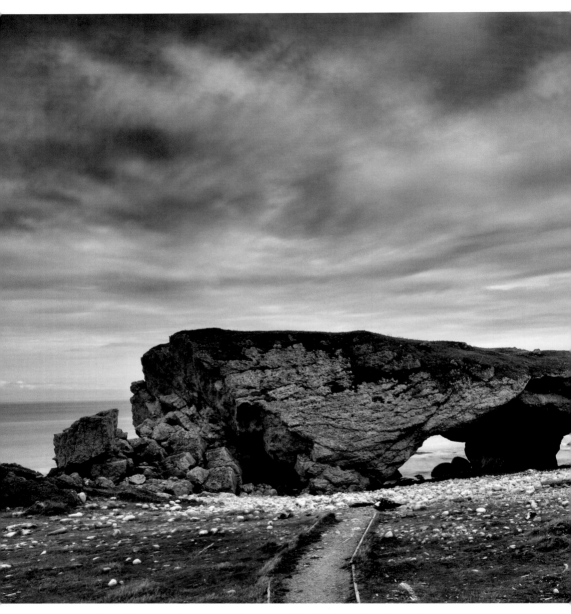

Shaped by encroaching waters, The Arches of the Great Northern Peninsula provide a spectacular foreground to a view of the Gulf of St. Lawrence.

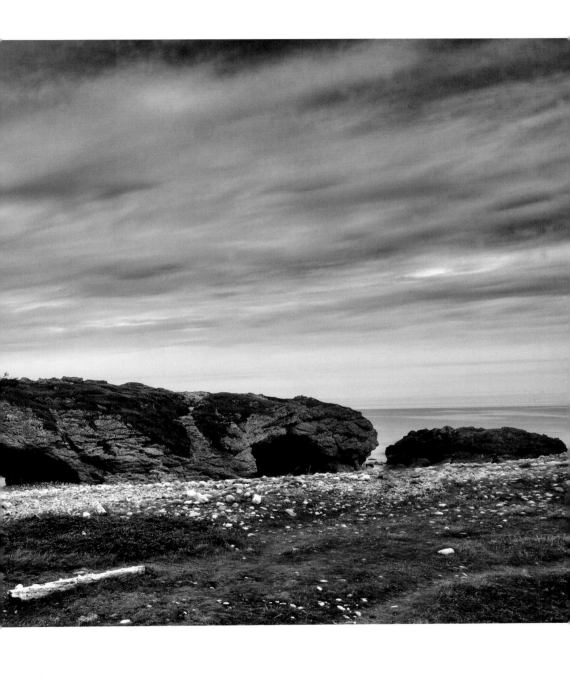

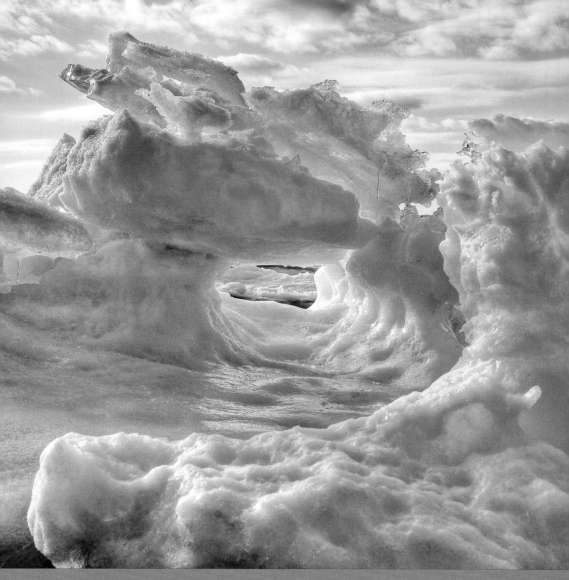

ABOVE: *The spring thaw sculpts a storm of shapes in Arctic ice that has drifted into the harbour at Clarke's Beach.*

OPPOSTIE: *Rose hips encased in silver thaw.*

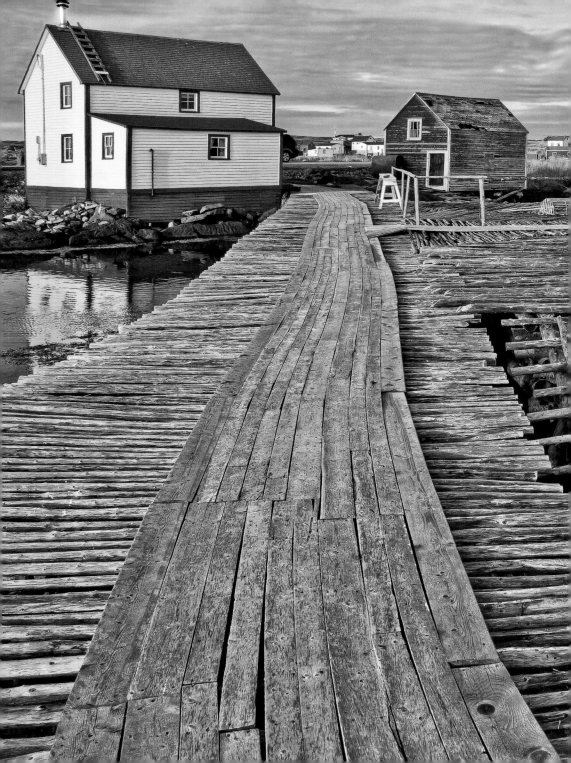

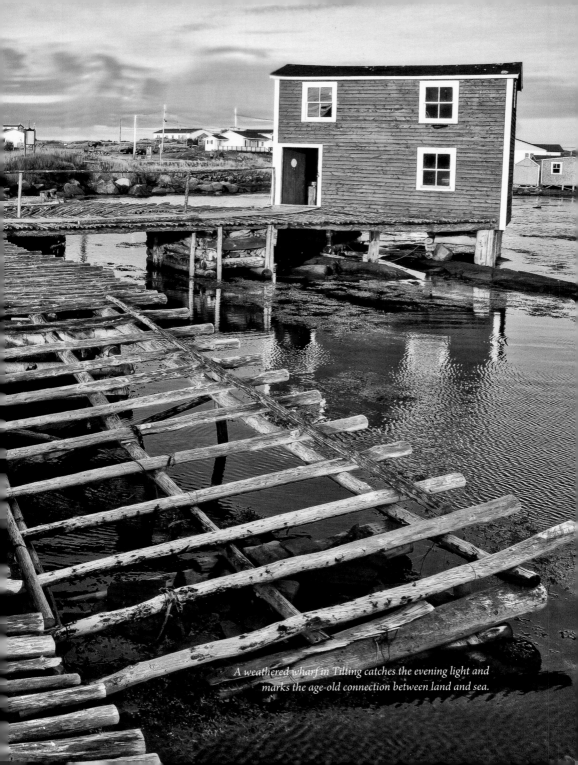

A weathered wharf in Tilting catches the evening light and
marks the age-old connection between land and sea.

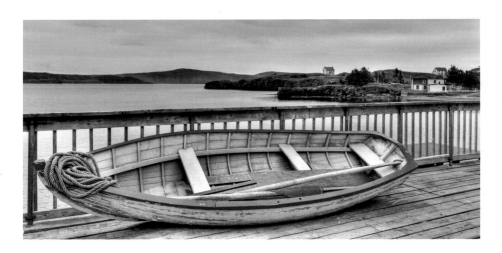

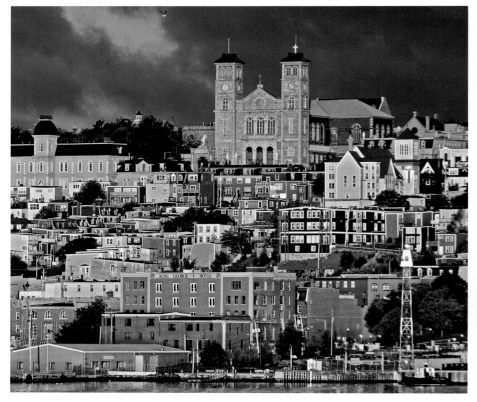

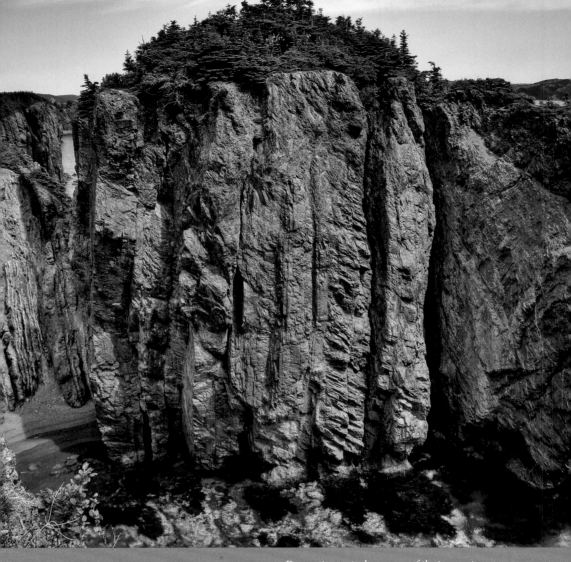

ABOVE: *Dramatic sea stacks are one of the impressive features along The Skerwink Trail in Trinity Bay.*

OPPOSTIE TOP: *A rodney with gunnels painted a vibrant red awaits repair in Trinity.*

OPPOSTIE BOTTOM: *The Basilica of St. John the Baptist overlooks the city as a rising sun illuminates the colourful row houses of St. John's.*

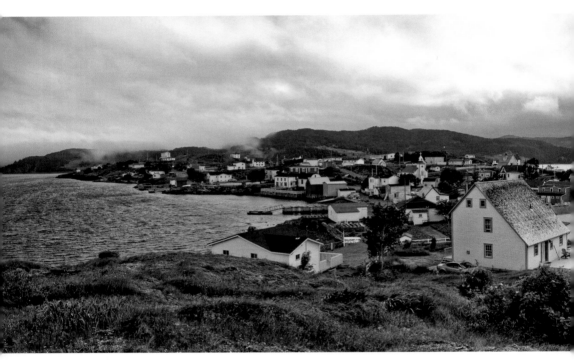

Newfoundland history comes to life in the scenic town of Trinity.

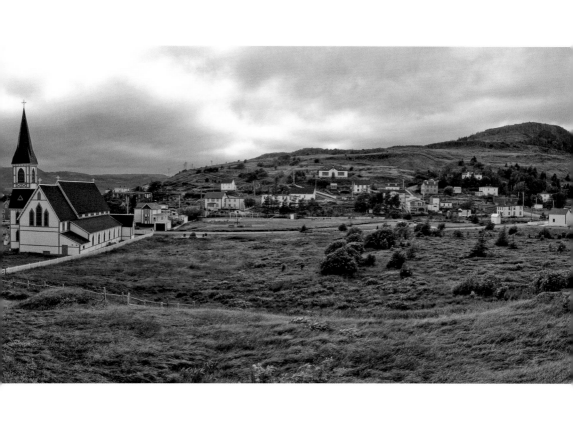

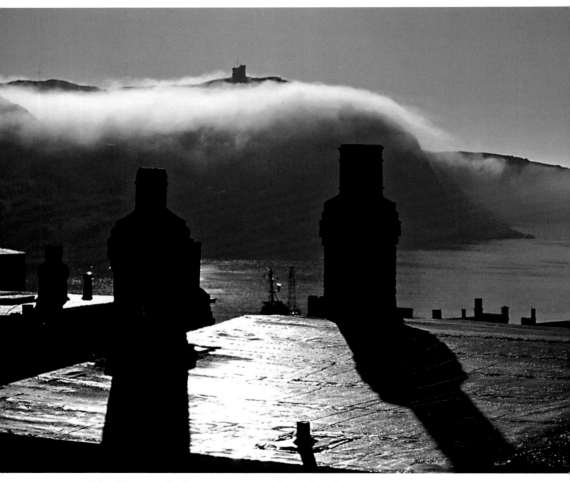

Cabot Tower stands above a morning mist that enshrouds
The Battery and Signal Hill.

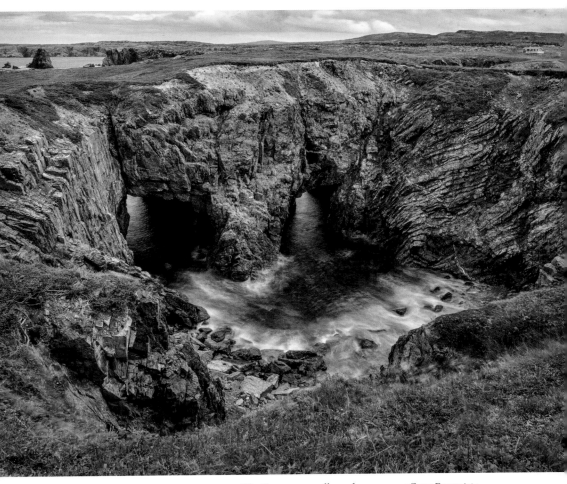

*The Dungeon, a collapsed sea cave on Cape Bonavista,
stands as a testament to the raw power of the Atlantic.*

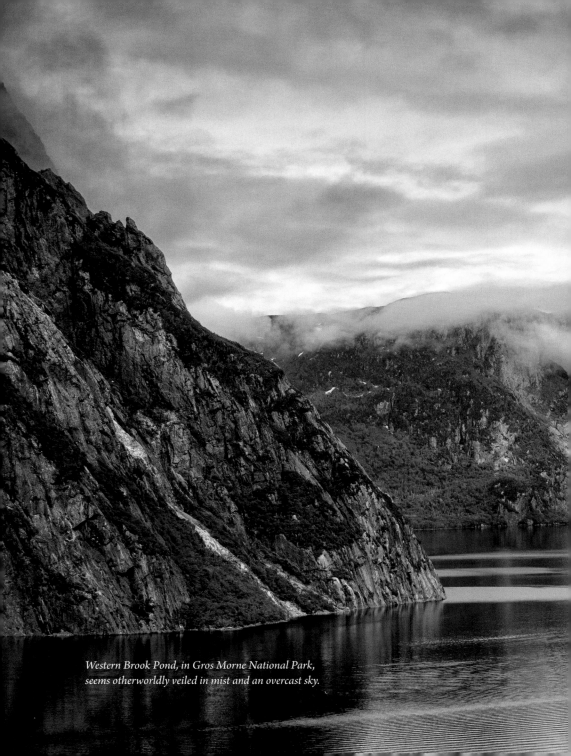

Western Brook Pond, in Gros Morne National Park,
seems otherworldly veiled in mist and an overcast sky.

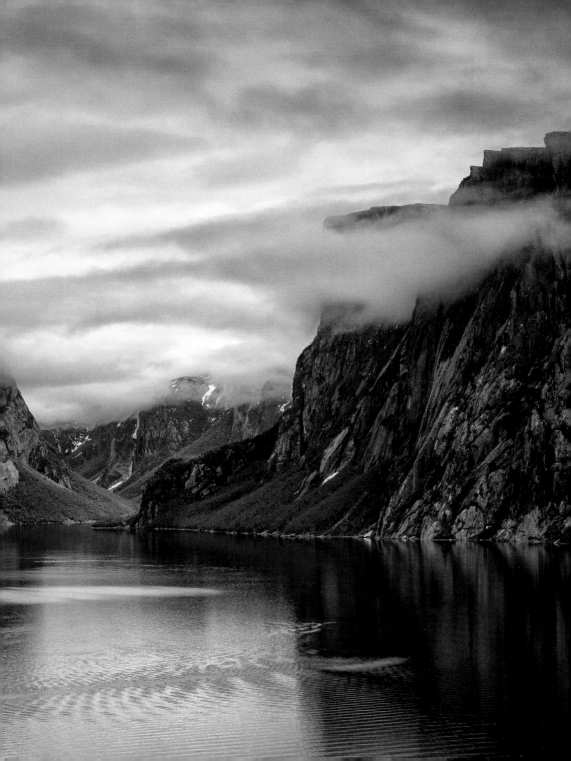

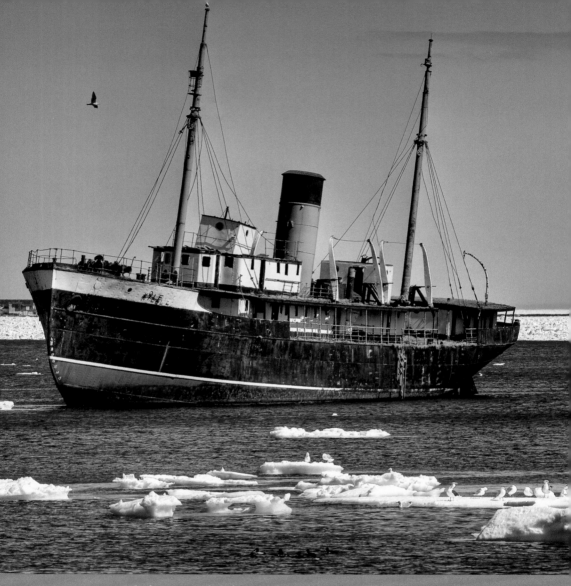

ABOVE: *The famous* SS *Kyle, a former sealing vessel and coastal boat, lies grounded as a well-known landmark in Harbour Grace.*

OPPOSTIE TOP: *A brilliant sunset in Conche where three boats face east.*

OPPOSTIE BOTTOM: *"Cuffs" and "vamps" drying on a line in Trout River.*

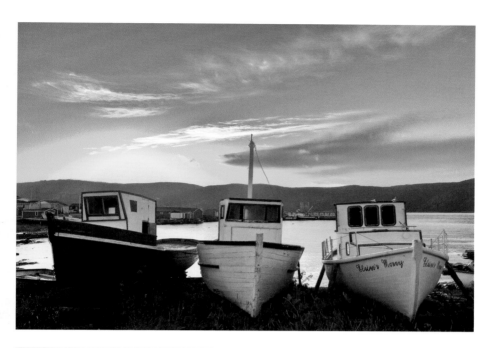

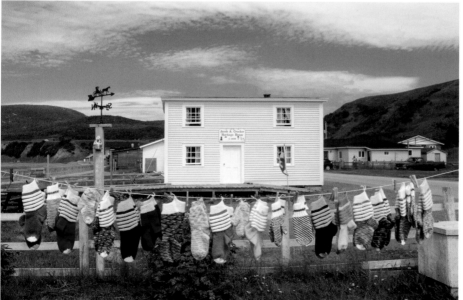

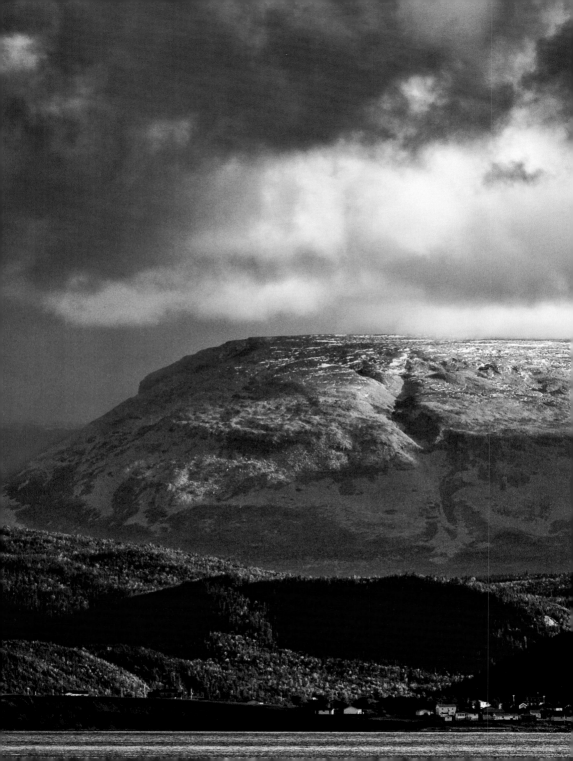

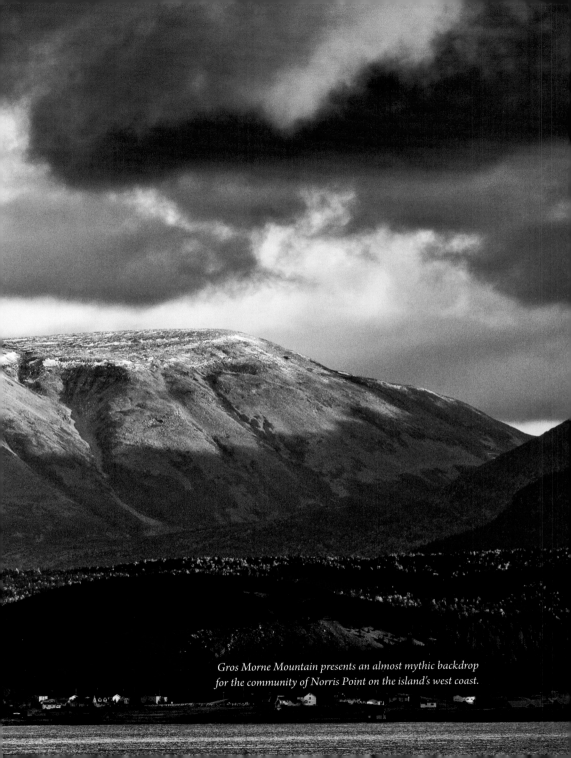

Gros Morne Mountain presents an almost mythic backdrop for the community of Norris Point on the island's west coast.

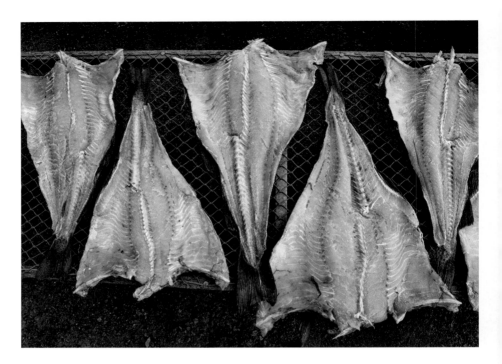

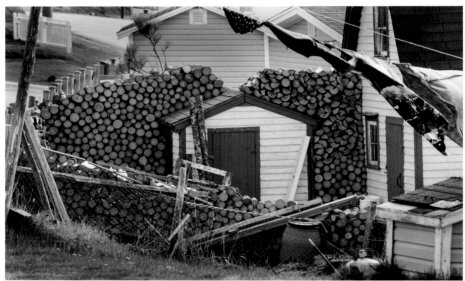

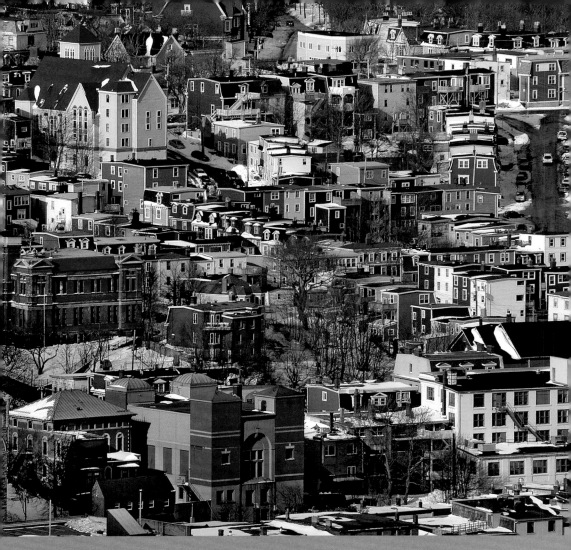

ABOVE: *The narrow streets and cheerful row houses of downtown St. John's offer remarkable views in the crisp air and natural light of winter.*

OPPOSITE TOP: *Split cod drying on a flake in the old tradition.*

OPPOSITE BOTTOM: *On a warm, early summer day, a well-stocked woodpile in Fogo presages winter.*

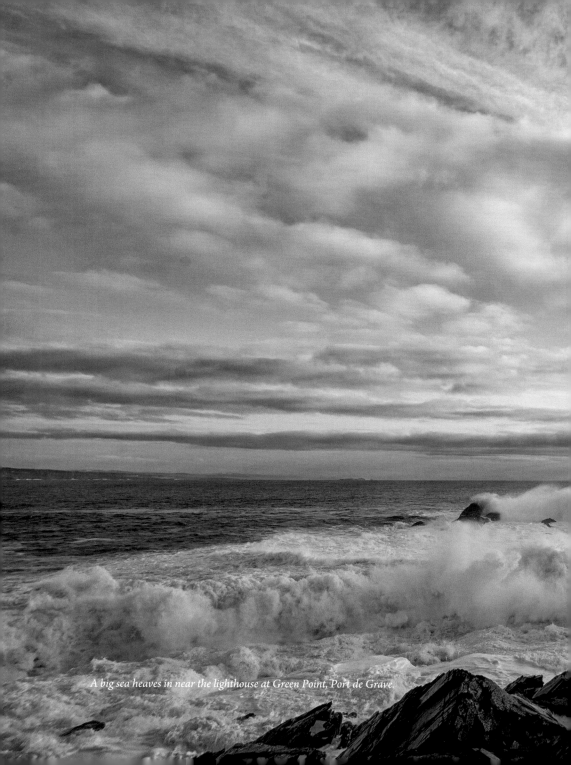

A big sea heaves in near the lighthouse at Green Point, Port de Grave.

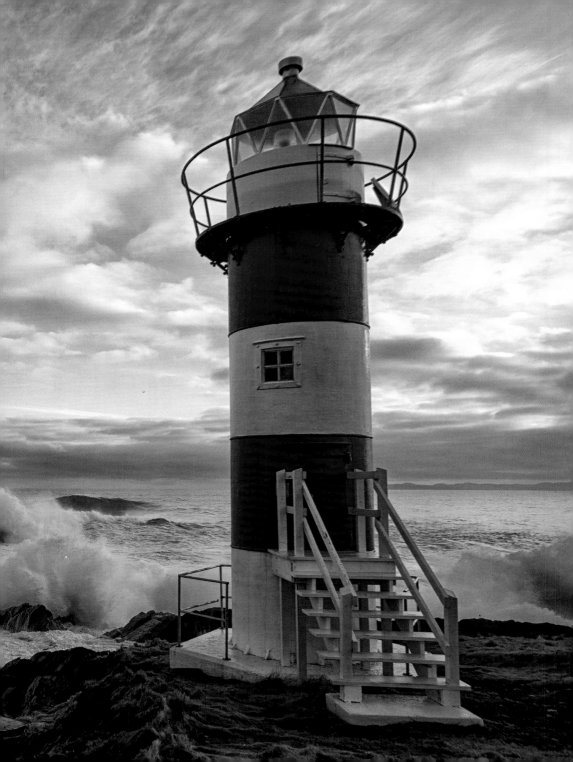

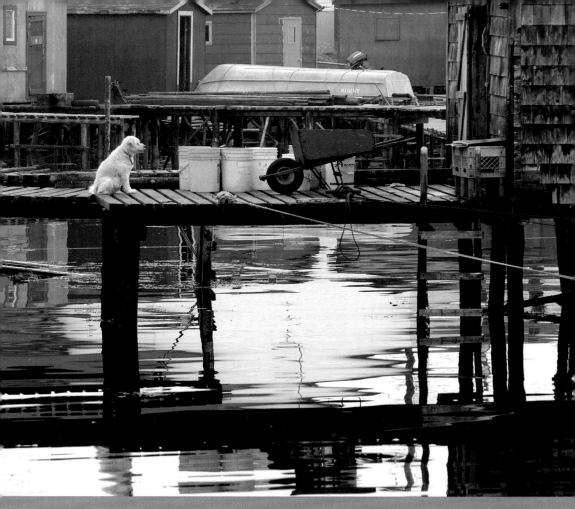

ABOVE: *A young dog waits with patience on a stilted fishing stage in Ramea.*

OPPOSITE: *Beneath a forever sky, trees take the shape of wind in Salmon Cove.*

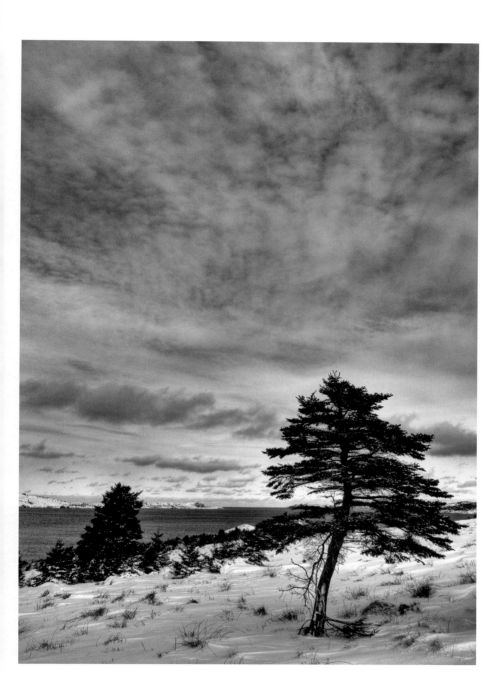

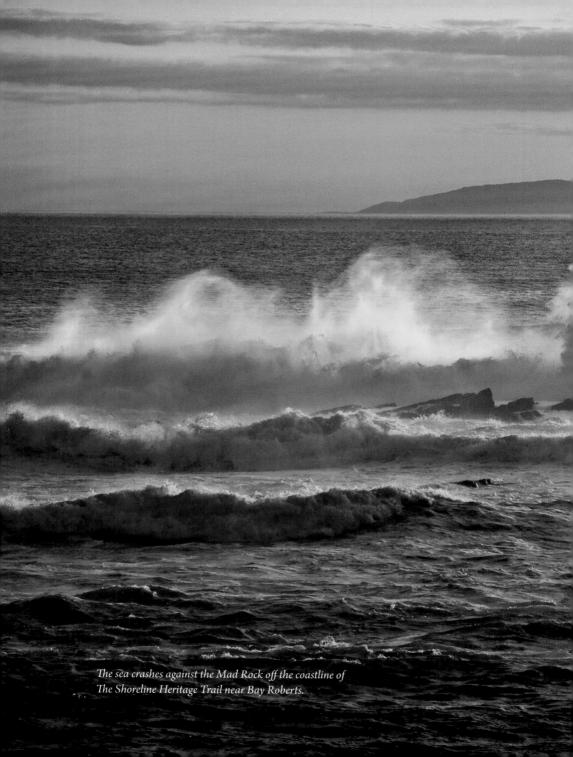

The sea crashes against the Mad Rock off the coastline of
The Shoreline Heritage Trail near Bay Roberts.

Breakwater Books
PO Box 2188, St. John's, NL, Canada, A1C 6E6
WWW.BREAKWATERBOOKS.COM

Library and Archives Canada Cataloguing in Publication
Minty, Dennis, author, photographer
Newfoundland : an island apart / Dennis Minty.
ISBN 978-1-55081-600-6 (bound)
1. Newfoundland and Labrador--Pictorial works. I. Title.
FC2162.M56 2015 971.80022'2 C2015-900391-1

We acknowledge the support of the Canada Council for the Arts, which last year
invested $157 million to bring the arts to Canadians throughout the country. We
acknowledge the financial support of the Government of Canada through the Canada
Book Fund (CBF) and the Government of Newfoundland and Labrador through the
Department of Tourism, Culture and Recreation for our publishing activities.

Printed and bound in Canada.